Colorado
Wildlife

A Postcard Book

FALCON®

GUILFORD, CONNECTICUT
HELENA, MONTANA

AN IMPRINT OF THE GLOBE PEQUOT PRESS

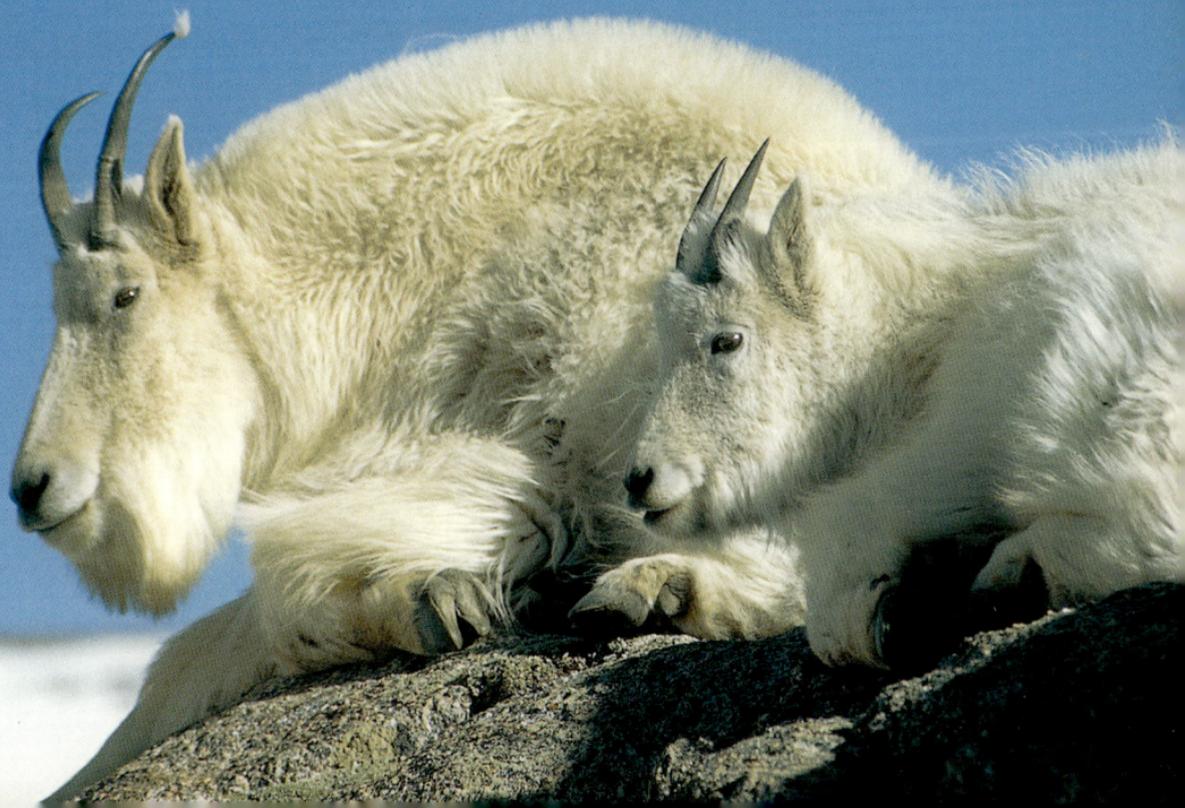

From this windy ledge near the top of Mount Evans, a
mountain goat nanny and her kid survey a vast expanse
of the Rocky Mountains.

Please Place

First-Class

Stamp Here

C O L O R A D O
W I L D L I F E

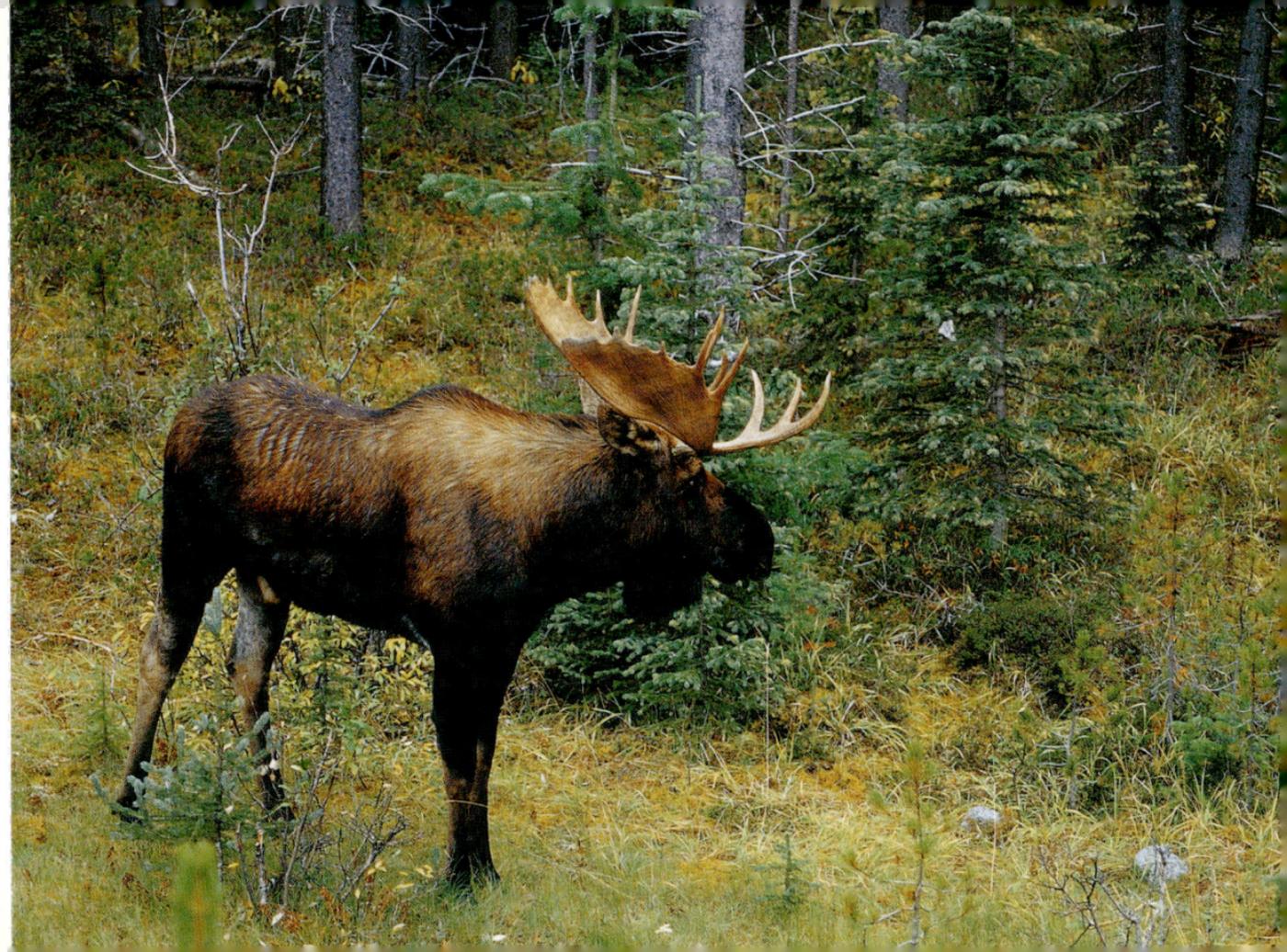

Although it is the smallest of North American moose, the Shiras moose nevertheless weighs in at an average of 1,000 pounds and stands more than 6 feet tall.

Please Place

First-Class

Stamp Here

COLORADO
WILDLIFE

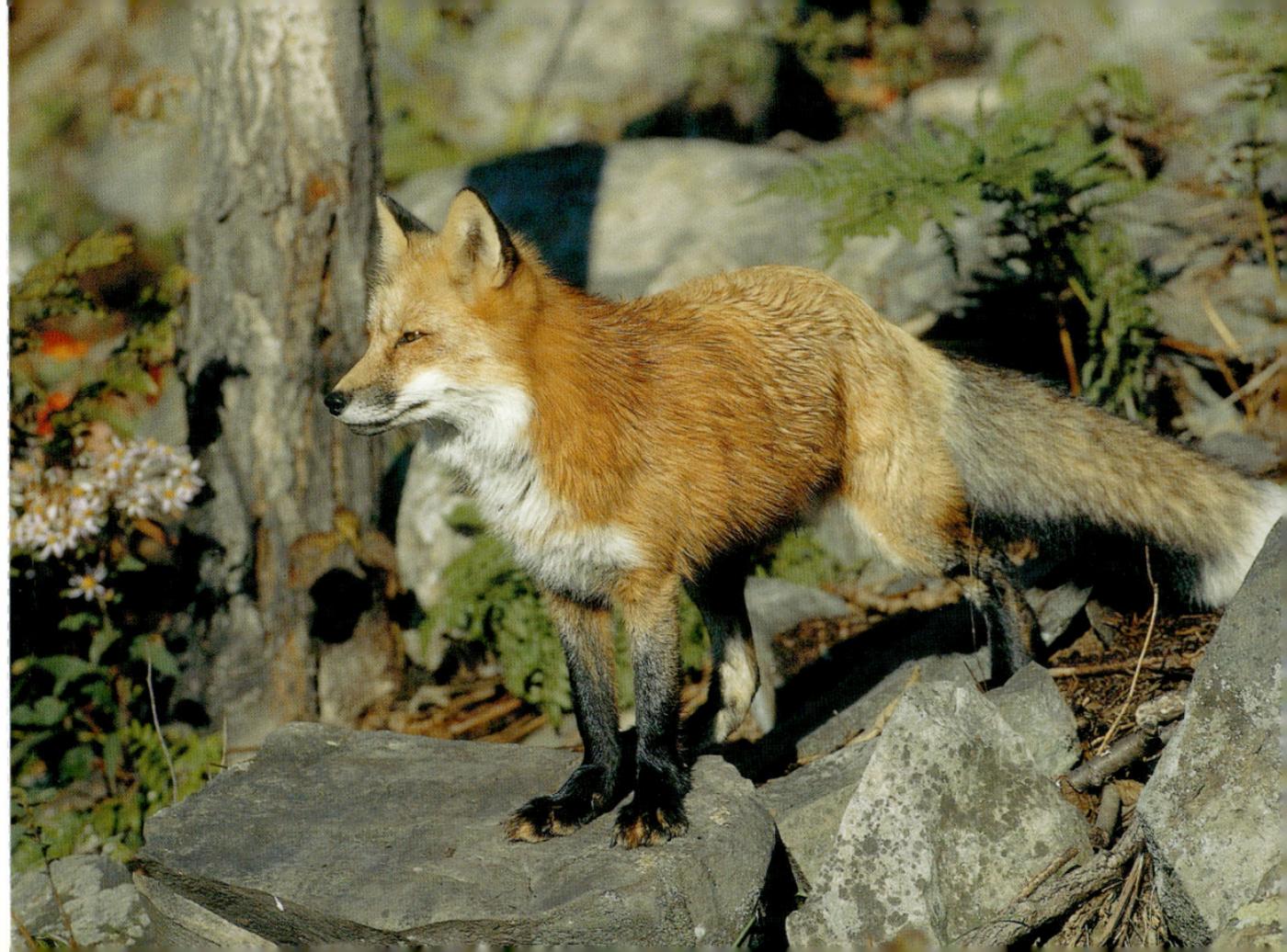

Red foxes are frequently sighted because they generally prefer open habitats and are not strictly nocturnal.

Please Place

First-Class

Stamp Here

COLORADO
WILDLIFE

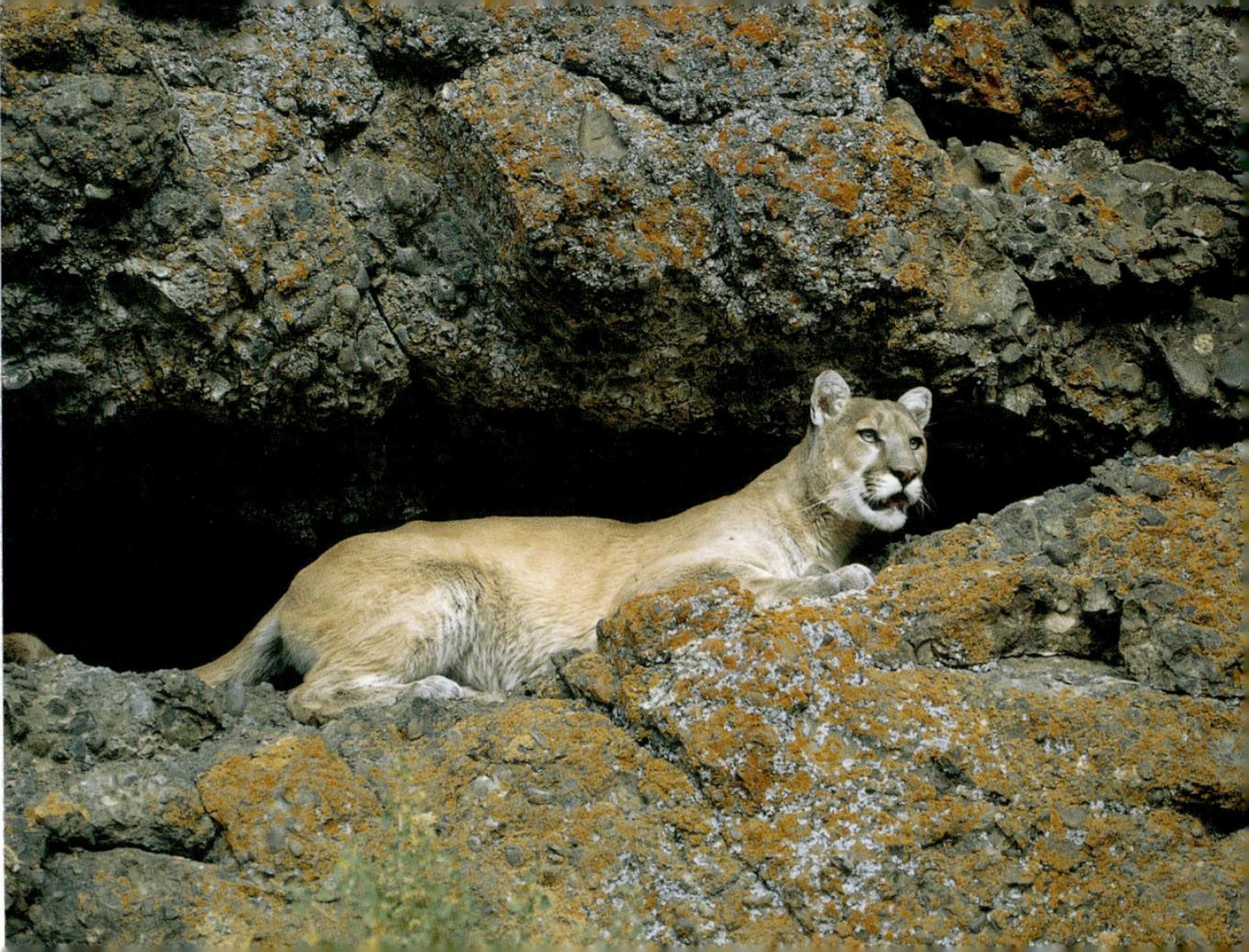

Mountain lions—also referred to as cougars, pumas, panthers, or catamounts—are magnificent hunters. At more than 6 feet long, they are Colorado's largest cat.

Please Place

First-Class

Stamp Here

C O L O R A D O
W I L D L I F E

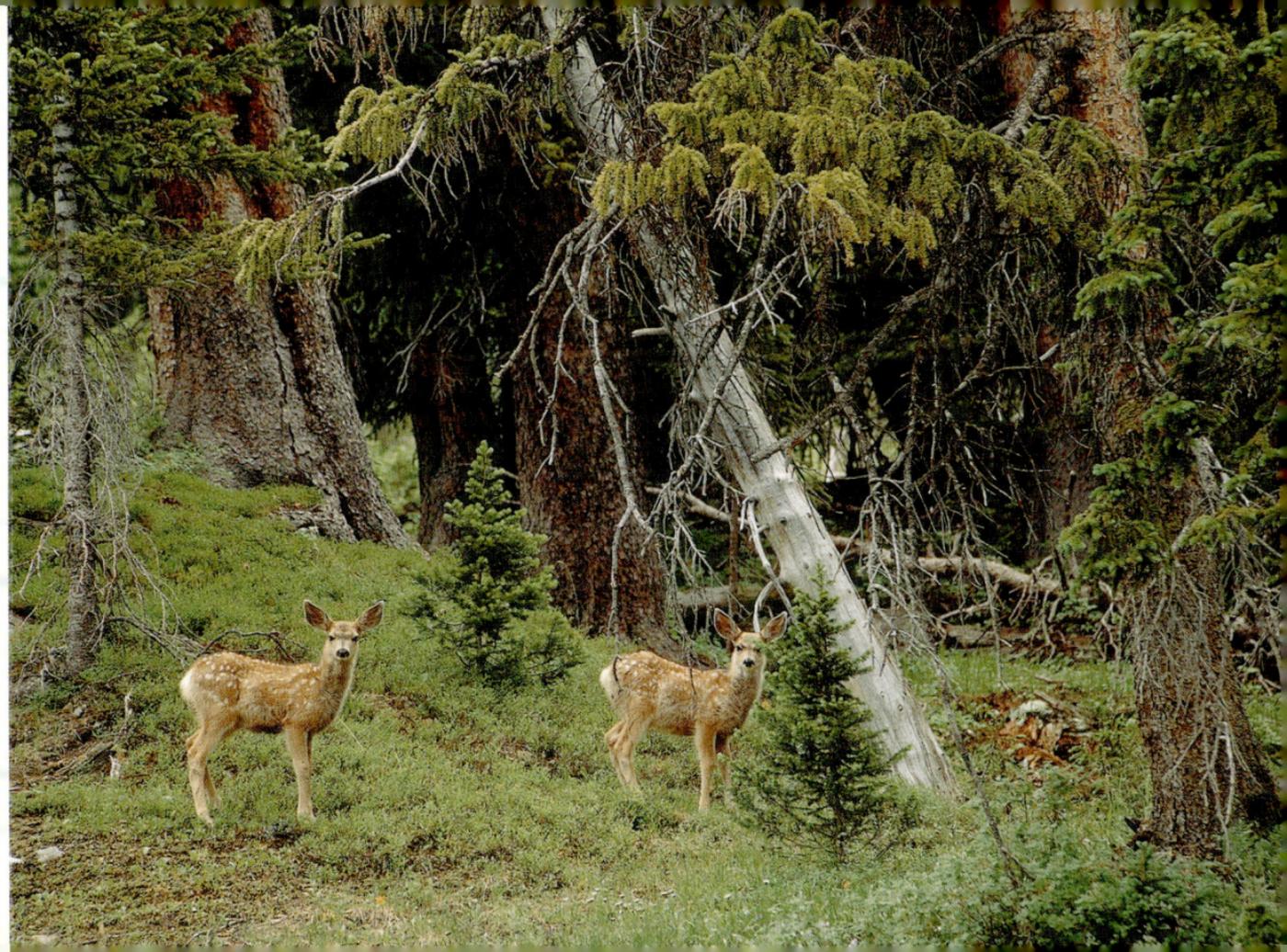

Mule deer fawns explore their surroundings in Rocky Mountain National Park. Mule deer have large ears that make them sensitive to sound. When startled, they leap so high they're known as "jumping deer."

COLORADO
WILDLIFE

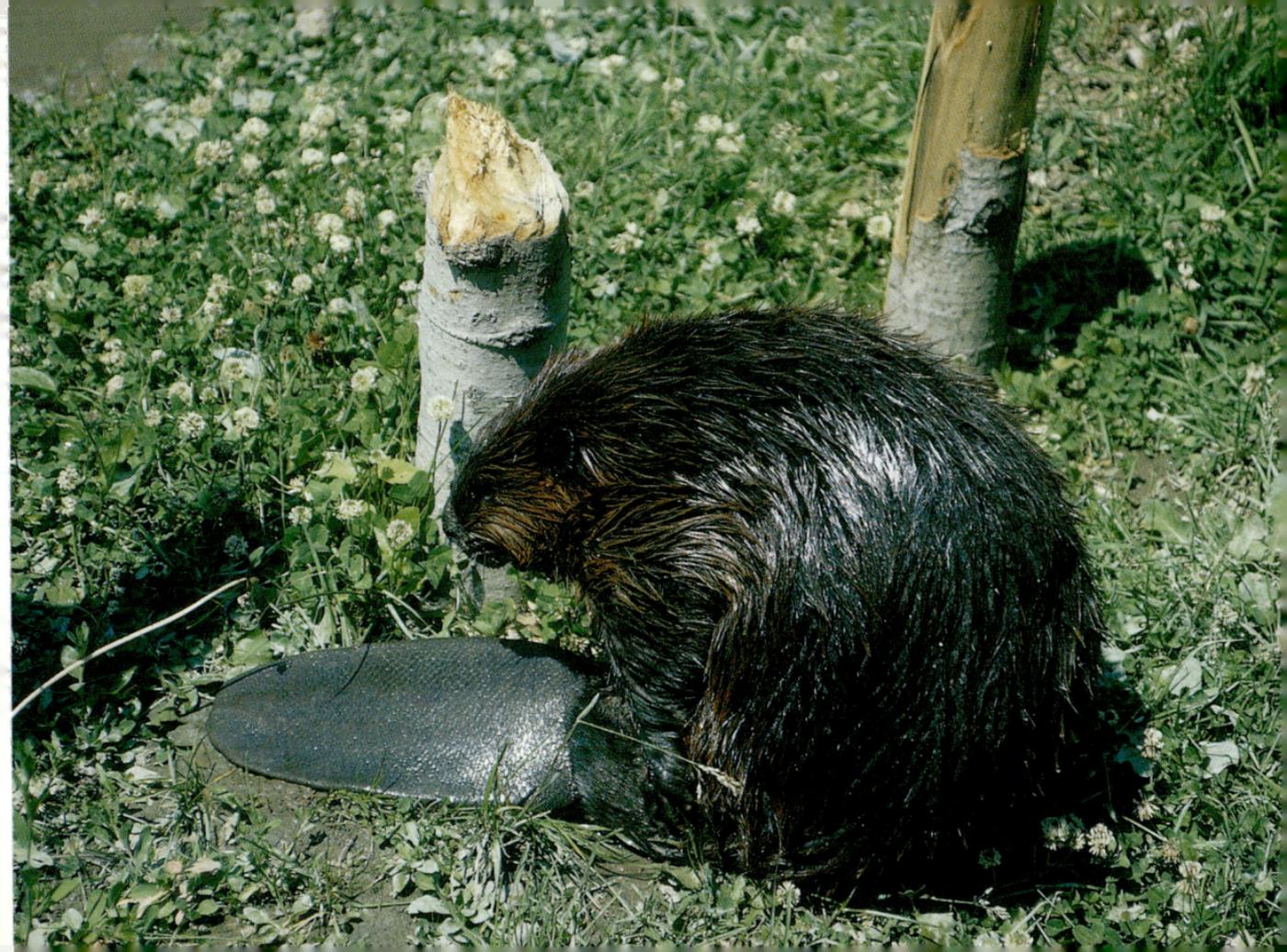

Beavers chew down and gather aspens and willows to use in constructing their mud dams and lodges. First they build the dams in rivers and streams and then add domelike lodges on top.

Please Place

First-Class

Stamp Here

COLORADO
WILDLIFE

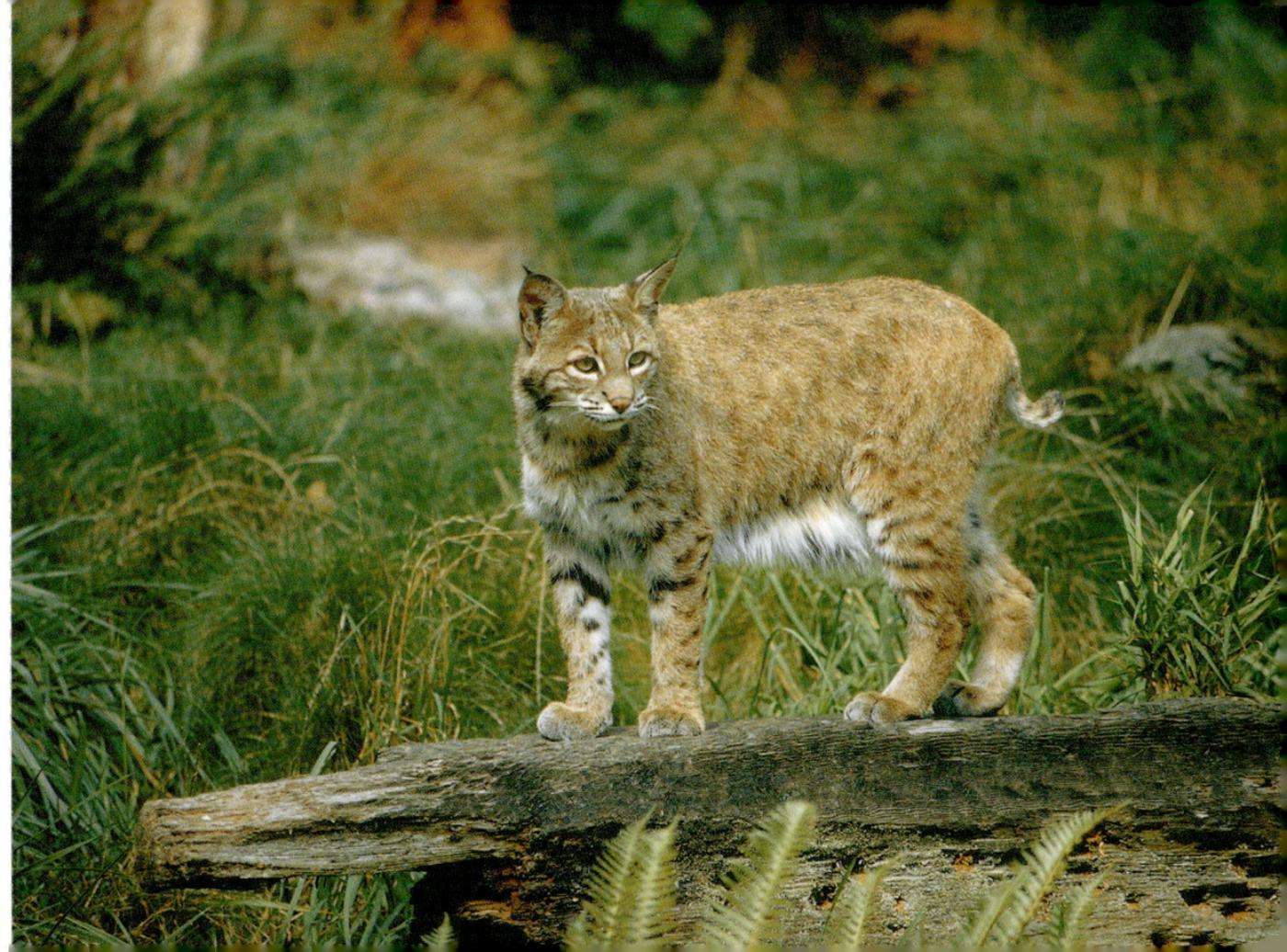

A common but solitary feline, the bobcat is found in mountainous and desert areas. It feeds on a variety of animals from small mammals (like ground squirrels and rabbits) to birds. The tip of its short tail is black on top and white underneath.

COLORADO
WILDLIFE

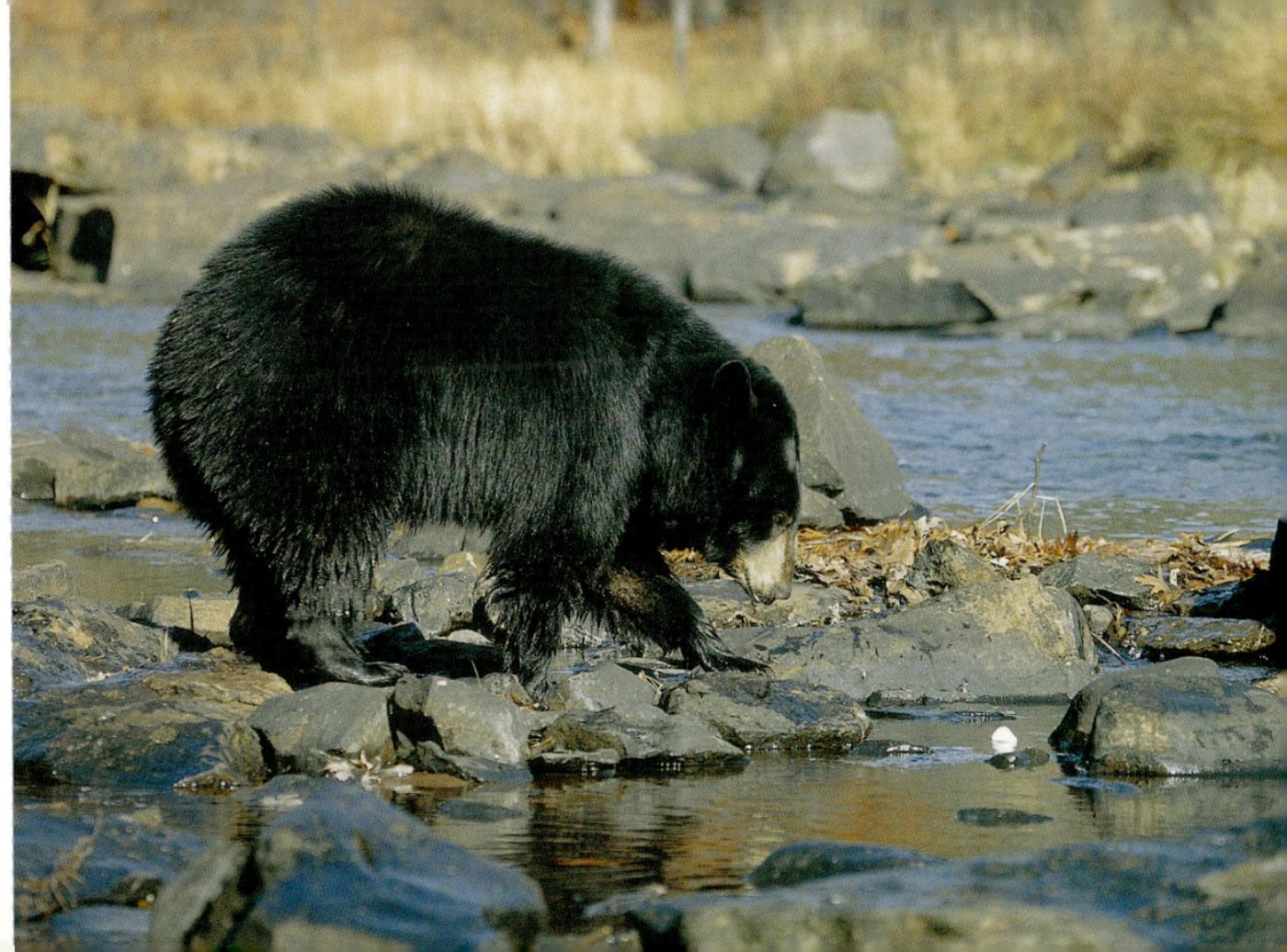

Although they are typically shy and easily frightened, black bears are good tree climbers and swimmers. They can survive more than twenty-five years in the wild.

Please Place

First-Class

Stamp Here

COLORADO
WILDLIFE

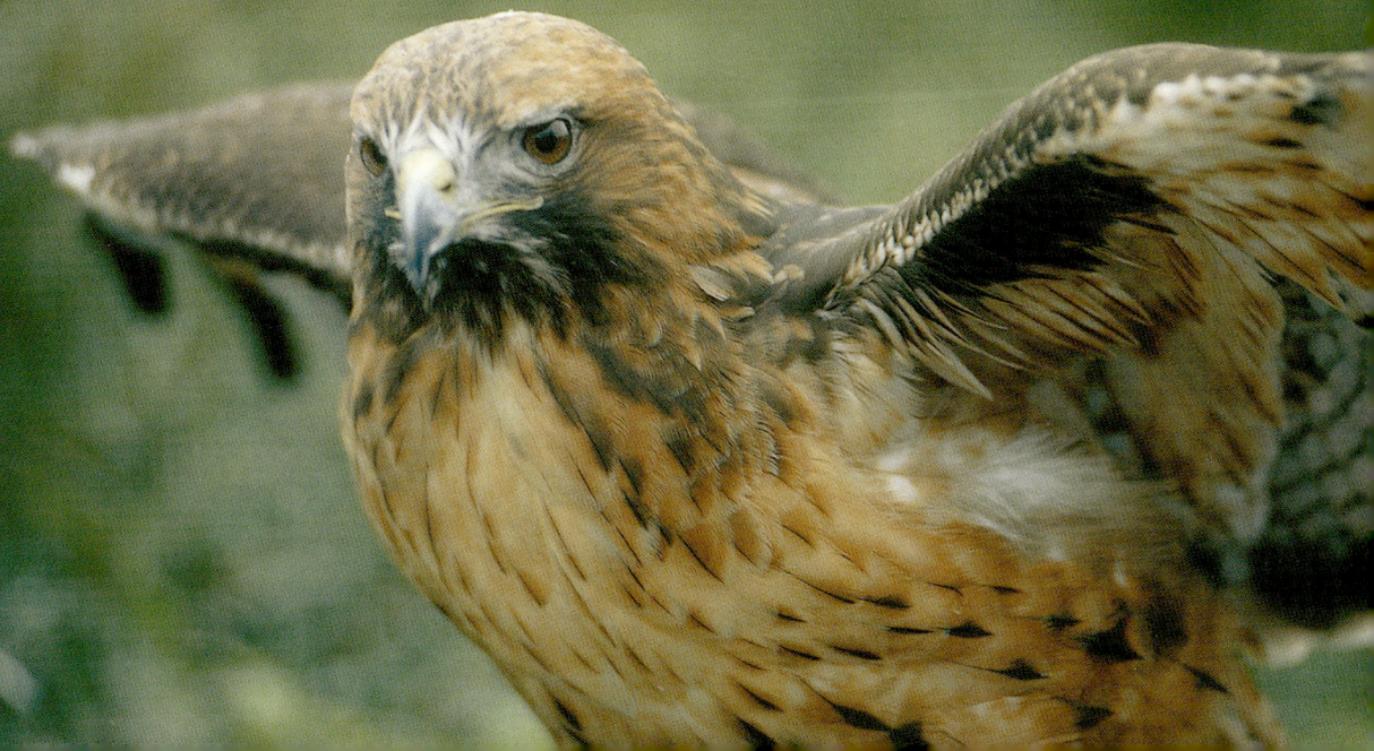

The most common hawk in North America, the red-tailed hawk soars with its wings raised slightly above horizontal, its flight slow and steady with deep wing beats.

Please Place

First-Class

Stamp Here

COLORADO
WILDLIFE

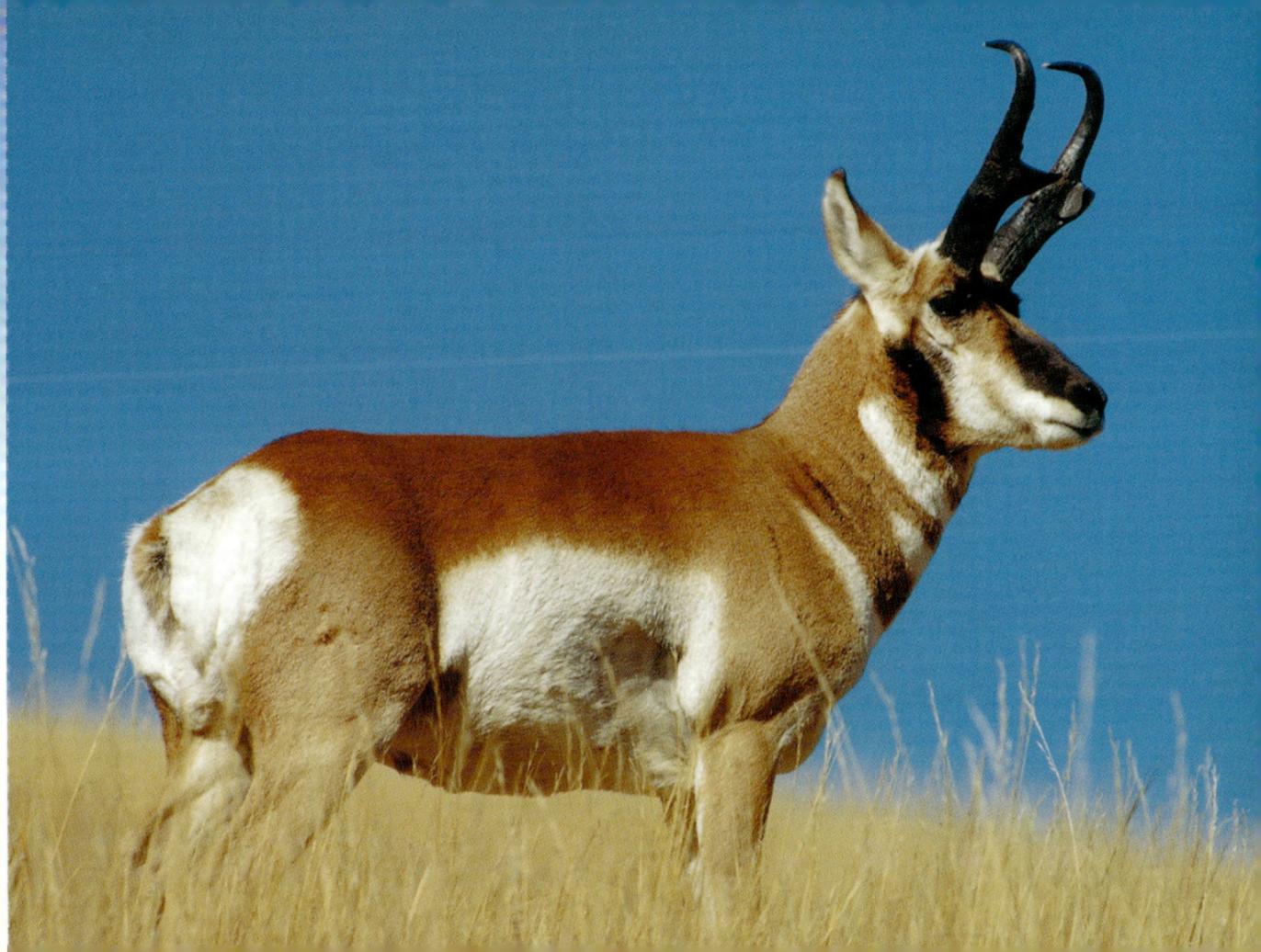

Pronghorn antelopes are the only surviving Antilocapridae, *a species whose other members all died out before the end of the last Ice Age.*

Please Place

First-Class

Stamp Here

COLORADO
WILDLIFE

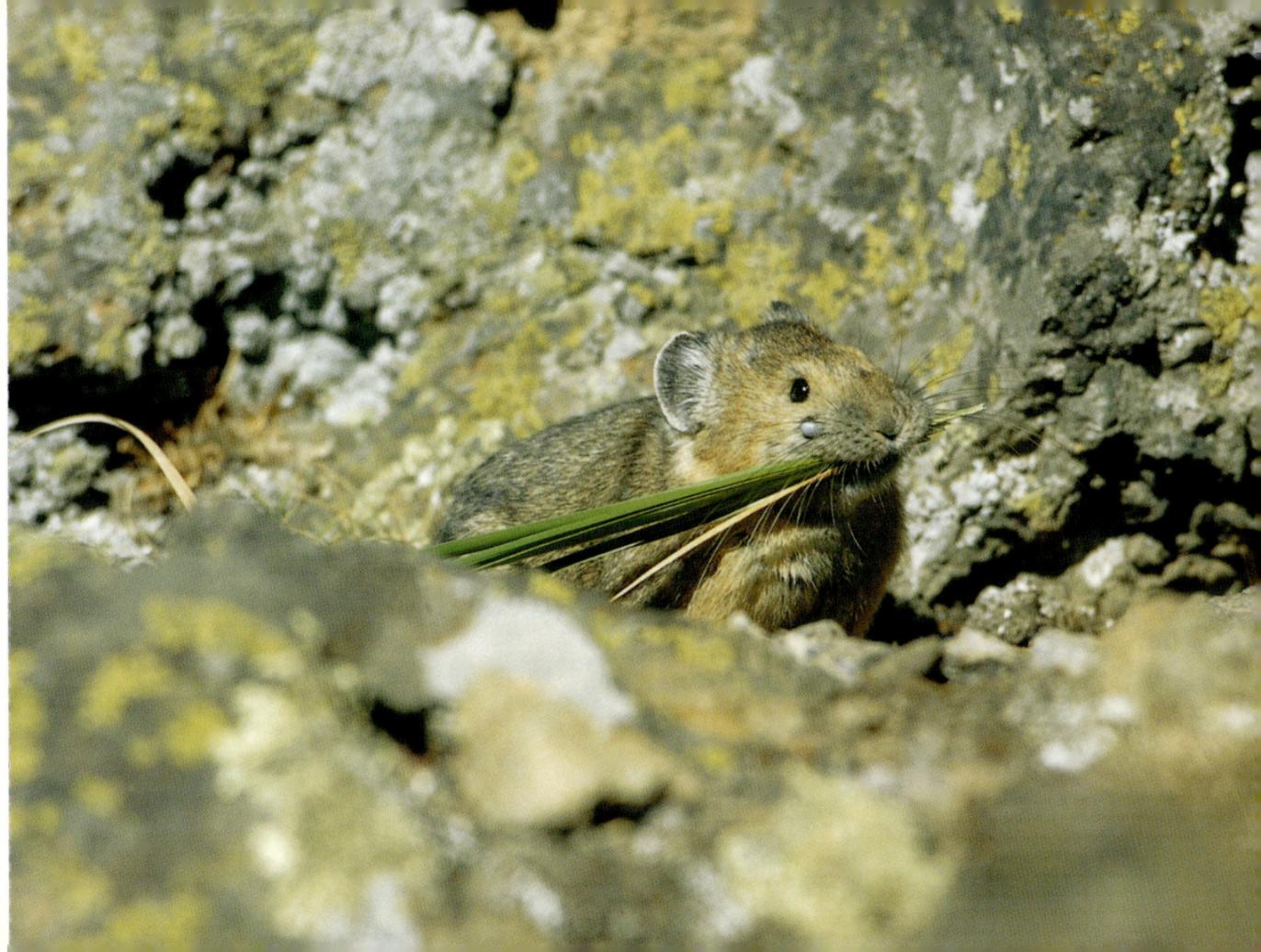

Because pikas—often heard squeaking in talus slopes—do not hibernate, they gather grass and other plants, dry them in the sun, and store them under rocks to ensure a food supply for winter.

Please Place

First-Class

Stamp Here

COLORADO
WILDLIFE

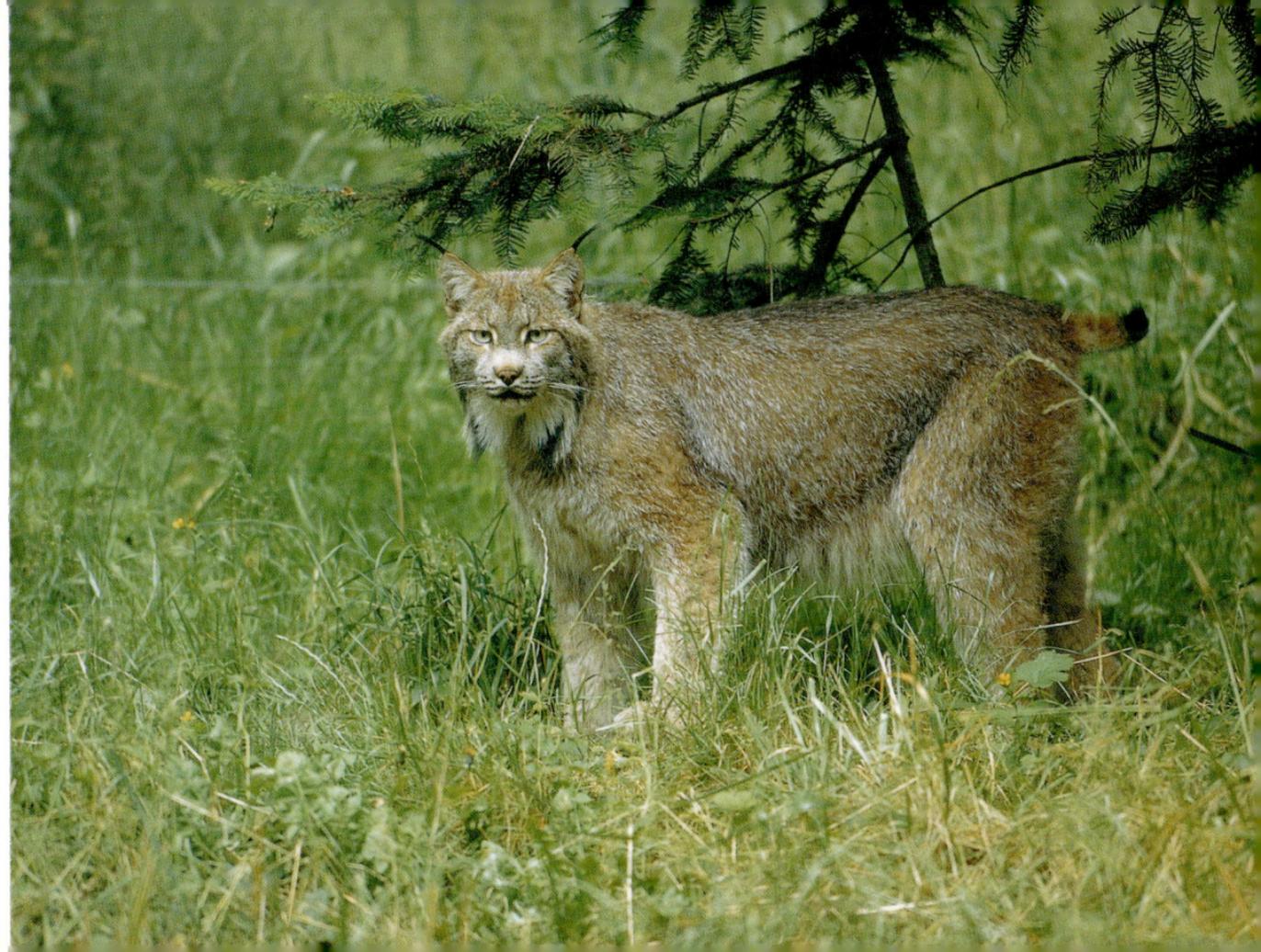

The lynx, a shy feline with large ruffs of hair on the sides of its face, can move well in deep snow, a trait that makes it well equipped to hunt its primary prey, the snowshoe hare.

Please Place

First-Class

Stamp Here

COLORADO
WILDLIFE

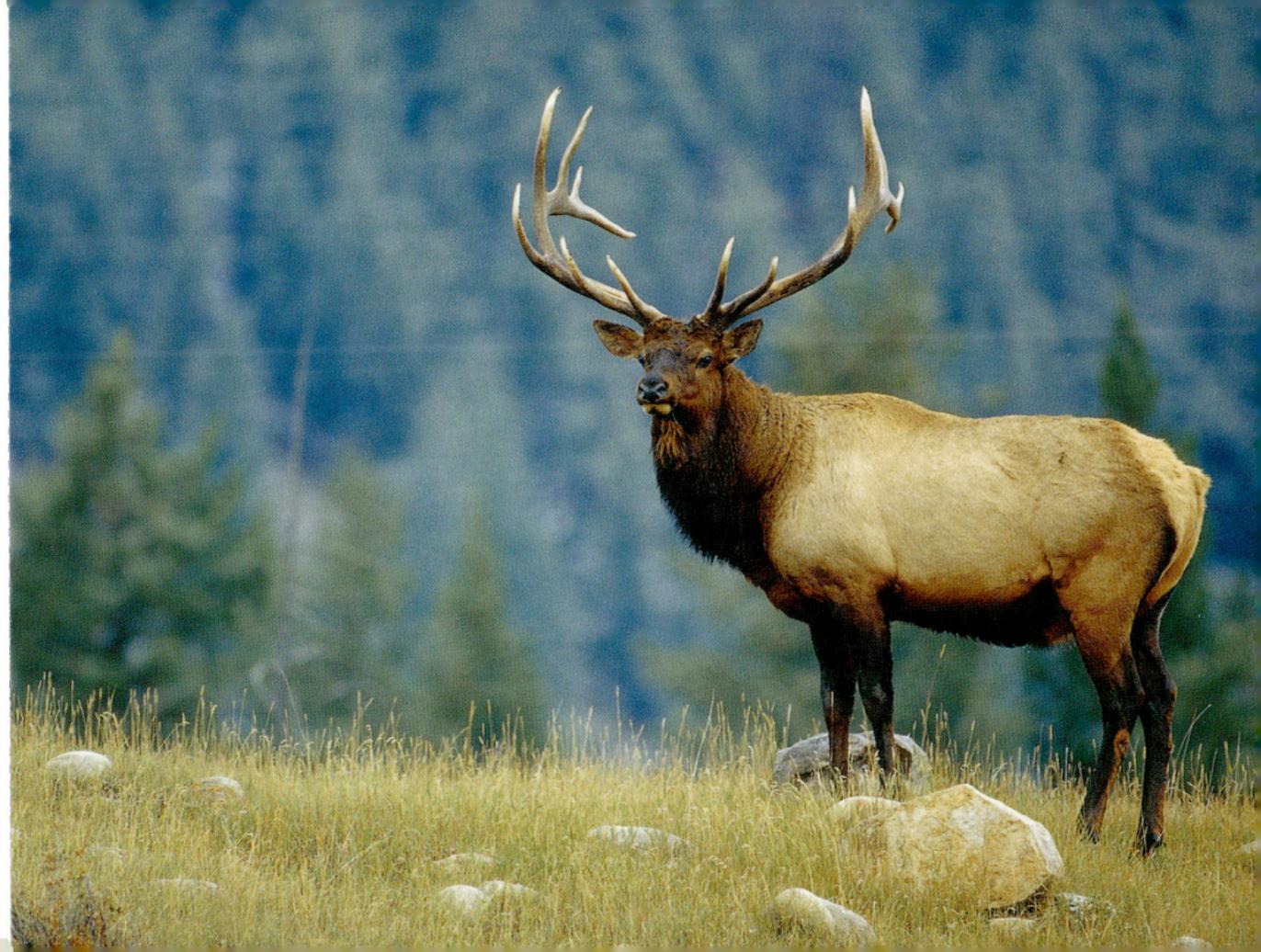

Rocky Mountain elk bulls have velvet-covered antlers that grow as long as 6 feet and weigh as much as thirty pounds. In early September mature bull elk start to bugle. This high-pitched sound is used in the elk's mating ritual.

Please Place

First-Class

Stamp Here

C O L O R A D O
W I L D L I F E

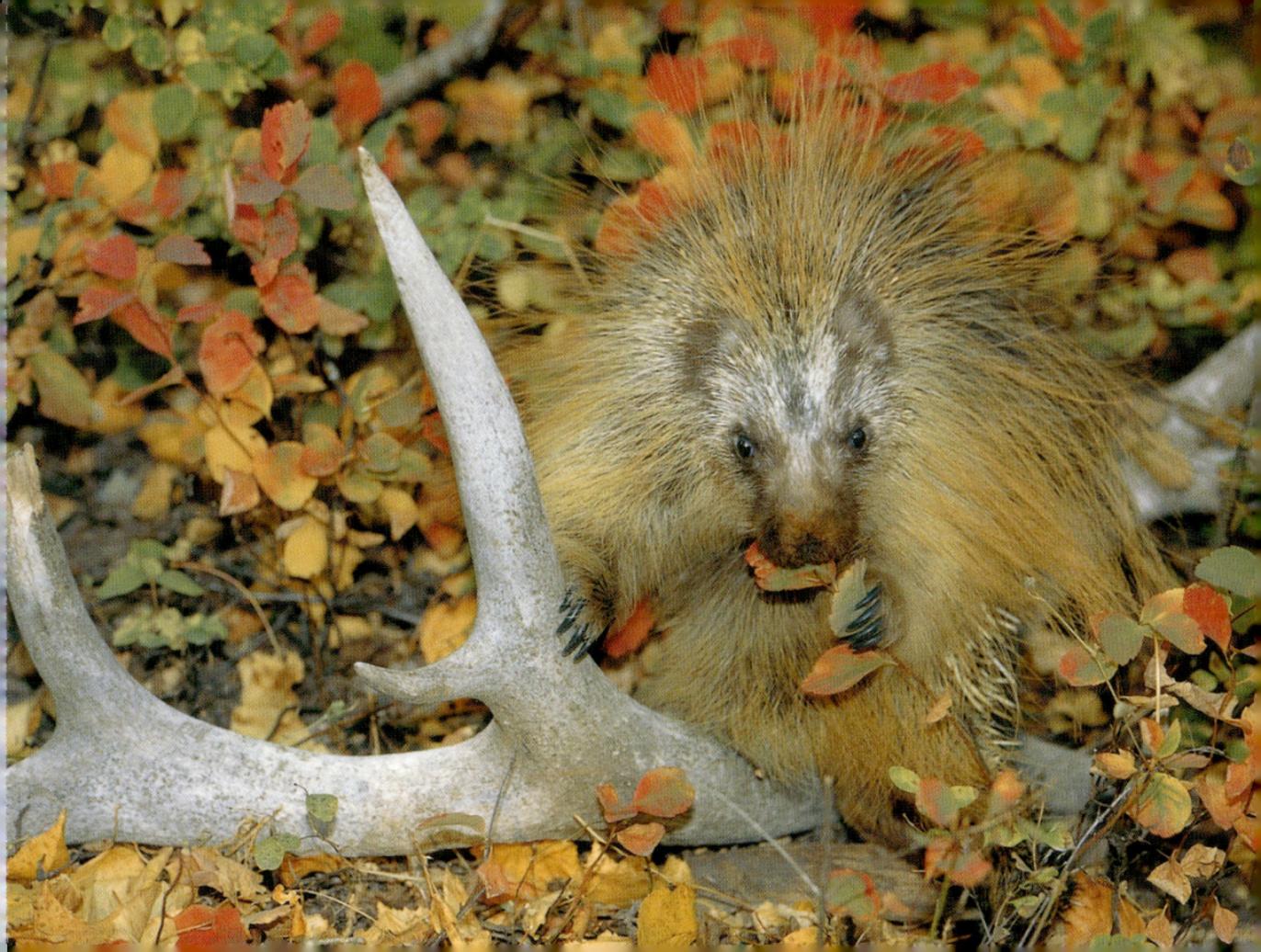

When porcupines are first born, their quills are soft, but they harden in about thirty minutes. The quills are hollow and buoyant, allowing porcupines to swim across wide streams without hesitation.

Please Place

First-Class

Stamp Here

COLORADO
WILDLIFE

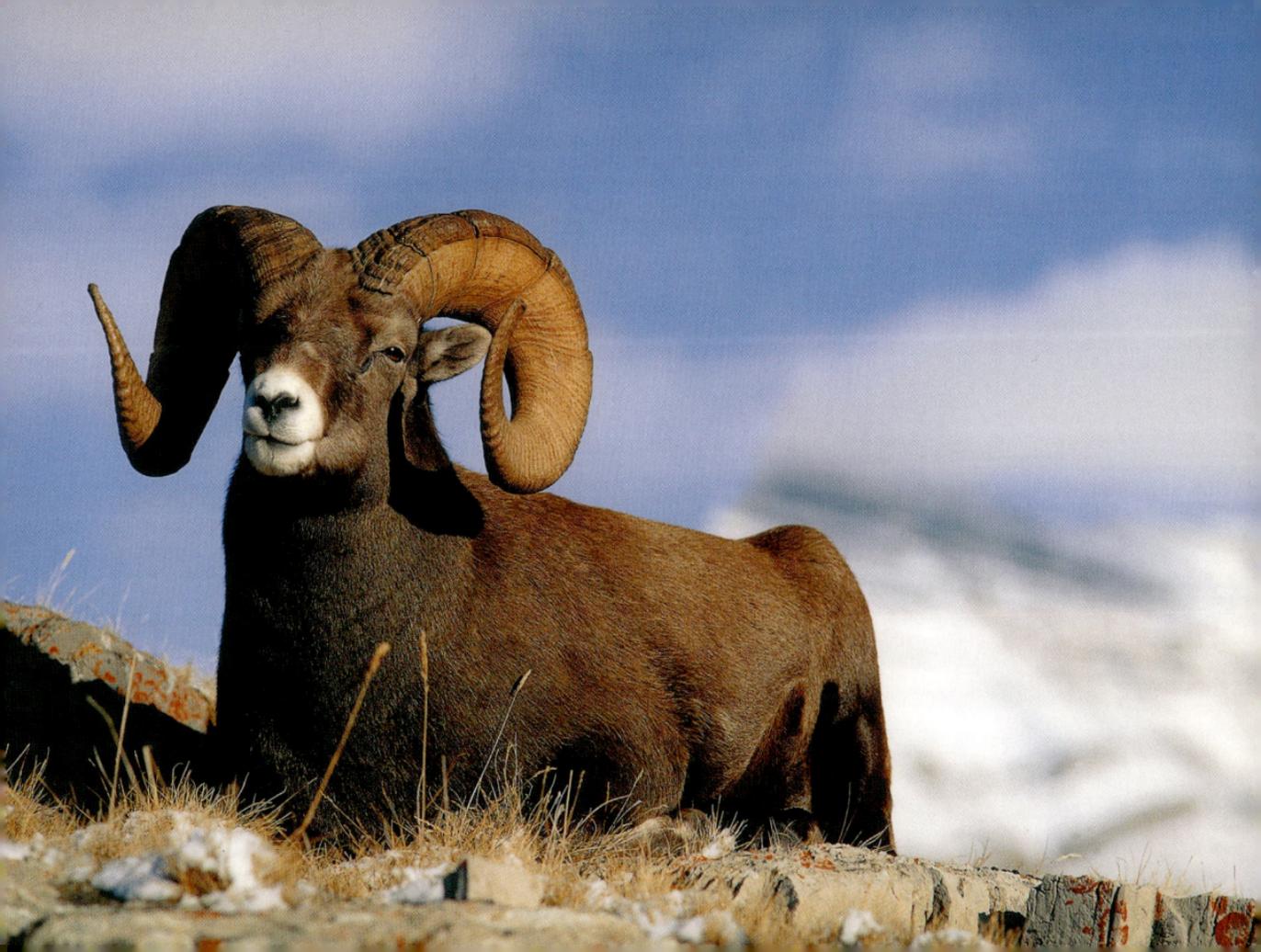

★ In the spirit of a solitary photographer taking a photo of something rare and fabulous, we—the dedicated folk of The Globe Pequot Press—offer you this nifty, galaxy-class postcard to help you remember how spectacular it all is. Because the truth is, we are collectors of treasures, each and every one of us. We go out there, we open our hearts and we long for little pieces of wonder to spread around and bring back home. This is how we make our lives bigger and more fantastic; and in this crazy world of ours, we need to do everything we can to savor the miracles and expand the bliss. Now send this little beauty out there so that others can get themselves a piece of the joy!

Rocky Mountain bighorn sheep—Colorado's state animal—have hair rather than wool to keep them warm high in their rough mountainous terrain.

COLORADO
WILDLIFE